D1488781

The Awakening Imagination:
Image, Idol, Object, Icon

Michael D. O'Brien

WISEBLOOD ESSAYS IN CONTEMPORARY CULTURE #8

Wiseblood Books

Adapted from a lecture, "Historical Imagination and the Renewal of Culture," given by Michael O'Brien at the "Catholicism and History" Conference, the Centre for Faith and Culture, Oxford, September 6, 1995.

Printed in the United States of America

Set in Baskerville Typesetting

Front cover: Plaque with Christ Receiving Magdeburg Cathedral from Emperor Otto I; Magdeburg Ivories from the 10th century; public domain.

ISBN-13: 978-1-951319-16-8

Non-fiction / Monograph

Wiseblood Books
Belmont, North Carolina
www.wisebloodbooks.com

The Awakening Imagination

Image · Idol · Object · Icon

Michael D. O'Brien

THE UNIVERSE, GOD'S CREATION, IS GOOD

ON SOME SUMMER NIGHTS I like to take my children up the hill behind our house. We live far out in the country, and no lights from other houses can be seen. The sky is like black glass: reflecting nothing, but dazzling with billions of stars and planets. At the crest of the hill we lie down on the grass. It takes a little time, but we eventually grow quiet and still. The children lie on my chest or snuggle under my arm and look up. We gaze up, up into the infinite pool which bears the stars into being. Above us, on especially clear nights, with the aid of a low-power telescope we can locate a tiny smudge of light, which is the closest galaxy. It is spinning, spinning, but it is so far away that one could look for a whole lifetime and not see it alter. There are other galaxies out there, I tell my children, that whirl into each other like discs blending in space without colliding. They pass through each other, those billions of worlds, at thousands of miles per second, yet they do not appear to move at all. The children can just barely believe it, but they do believe it because I am their father and they trust me.

"The universe is deep," I tell them. "You can look into it forever."

And so they look with new eyes. The interior eye adjusts, and they see what it is so difficult for us adults to see: existence is not one-dimensional, or two-dimensional, or three- or five-dimensional. Creation is not a flat theatre backdrop to our lives. It is deep. You can look into it forever.

A few weeks ago I was visiting at the home of a family who live on a farm down the road from where we live. They had recently moved there from the city, and it was their first experience of living in the countryside. The father of the family and I were engaged in a heated theological debate when the door flew open and his twelve-year-old son burst in, I should say floated in. The boy's eyes were full of tears. His mouth was open wide, unable to speak for a few moments. We stared at him. His face was full of wonder, his arms raised in a gesture that

bore a remarkable resemblance to the ancient *orans* position of prayer, a timeless, mute reaching for transcendence.

"Oh Papa," he whispered, "I have seen the most beautiful thing. I have seen a *deer*."

It is impossible to convey the sense of awe with which he breathed this word. We stared at him, wondering what he meant. A deer? We have all seen deer. Then my neighbor and I looked at each other and understood that perhaps, after all, we had not ever really seen a deer: at least not in the way this child had just seen one. And later there came the revelation to both of us that we, with our prodigious intellects and our fiercely defended positions, often talk about things we have not really seen, or known, or loved well. We have pictures in our mind that form concepts and ideologies. We are clever, articulate impressionists, but we have not gazed into the liquid galaxies of a wild creature's eyes as it gazed back equally uncomprehending upon us. We have not stroked the red velvet hide. We have not touched the bone antlers and felt them toss. We have not seen the leap, the bolt into the sanctuary of the trees.

There are times in the summer when my children go out in the dusk, dancing around on tiptoes, leaping like Nijinsky, chasing fireflies. If they succeed in capturing a few, they bring them home in jars, and they drift off to sleep gazing at the phosphorescent light, startlingly bright, a fabulous bestiary, unexplainable and totally captivating—a covey of fireflies winking off, then on, then off, then on, contrapuntally in the dark of the children's bedrooms. Who is the captor, who the captive?

Six times I have attended the birth of my children. Each time as they emerge from the womb there comes from some unknown source within me and my wife an upwelling, a fountaining of wonder, reverence, tears, laughter, exultation. A new being has shown its hidden face and begun to assert its identity. O marvel of marvels, this child is ours and yet not ours. He is from our flesh, and yet he is so much more than us. Who is he? Where did he come from? This miraculous being, never before seen, never to be repeated, is an epiphany of the infinitely creative mind of God.

ART AS AN EXPRESSION OF BEING IN CREATION

In his book *Painting and Reality*, the Thomist Etienne Gilson says that each work of art is a new created being. This is precisely so. Although it is not conscious, organic being, it has presence. It has identity. It occupies space. It is unrepeatable. It pushes back the darkness by simply being there. And according to its fidelity to reality (implicitly or explicitly), it expands the realm of light by the authority of its *word*.

It is a commonplace that written into creation are words. What do they say? Where do they come from? Nature contains metaphors of a higher order, an order that animates creation and originates beyond it. We swim in a tropical sea of such signs, some easily read, others posing difficult questions. But in all situations, Nature reminds us of the primal lesson that existence is inexpressibly beautiful and undeniably dangerous. We are not in charge here. We are subject to a sometimes bewildering complex of laws. Only a fool or a madman will assert that nature is an expression of his own mind.

Cro-Magnon man crouching in the caves of Lascaux knew this well, though he would not have been able to articulate it. When he smeared charcoal and pigment on the stone walls, depicting the heaving gallop of deer and bison, he was performing a task that has rarely been surpassed for sheer style, purity, authenticity, and perception. This is immanent experience and transcendent experience meeting in the drama of the hunt, of one creature wrestling for the life he would extract from the death of another. This is more than a news item about food gathering. This is more than a tale about hunger filled. This portrait speaks to us across thousands of years with an immediacy that communicates the rush of adrenaline, the terror, exultation, feasting, gratitude, power, and longing. Depicted here is the search for permanence and completion, and also a witness to the insufficiency that greets us again each morning. This is a probing of the sensitive, mysterious roots of life itself. And the little stick men chasing the galloping herds across the wall are a singular

message about where prehistoric man placed himself in the hierarchy of being. That he could paint his marvelous quarry, that he could thus obtain a mastery over the dangerous miracle, must have been a great joy and a puzzle to him. That he portrayed his quarry as beautiful is another message. The tale is only superficially about an encounter with raw animal power. The artist's deeper tale is about the discovery of the power within him—man the maker, man the artist! This was not prehistoric man watching primitive television. This was religion.

I do not have much sympathy for the ideas of men such as Carl Jung and Joseph Campbell, although many of my fellow artists do. They have written a great deal about the role of symbol and myth. In this regard, I think they are on to a true insight when they speak of the centrality of those faculties in the human psyche. But the insight is limited: Campbell, for example, has written that "all religions are merely misunderstood mythologies"—please note the word *all*. G.K. Chesterton once pointed out, in his 1903–1904 controversy with Robert Blatchford, that the modern mythologists' position really adds up to this: Since a truth has impressed itself deeply in the consciousness of many peoples of varying times, religions, and cultures, then it simply cannot be true. The new mythologist, he said, has failed to examine the most important consideration of all: that people of various times and places may have been informed at an intuitive level of actual events which would one day take place in history; that in their inner longings there was a glimmer of light, a presentiment, a yearning forward through the medium of art toward the fullness of Truth that would one day be made flesh in the Incarnation. Perhaps mythologists, more than their pupils, need to be demythologized.

When I was a youth my family lived for several years in the high Canadian Arctic, hundreds of miles above the tree line, in a small Inuit (Eskimo) village. I recall the material impoverishment of the Inuit people during those years. So many of them lived in igloos and cardboard shacks during the nine months of winter, and in caribou skin tents during the very brief summer. Their possessions were few, but often

beautifully made. Stone lamps for burning seal oil were ingeniously designed and flawlessly symmetrical. Carvings of animals, birds, human and mythological subjects were of unsuspected eloquence and elegance, a haunting new language for the heart and eye. I can still remember one black, shining carving that must have weighed six or eight pounds in the hand, a tumbling convolution of heart-stopping perfection that depicted a terrible and beautiful thing. The toothless old woman who carved it grinned at me as we sat beside her fire in a tent on the shore of the Arctic Ocean. She sat on an empty packing crate scavenged from the Hudson Bay Company outpost, surrounded by stone shavings, her scrapers and knives, and the smell of decaying smoked fish, while willow twigs snapped and burned under a boiling tea kettle. She called her carving "Man Wrestling With Polar Bear." In the North men do not wrestle with bears. In such encounters men always lose. This image was a solid metaphor of the interior wrestling which is our abiding condition and calling: Courage overcoming fear. Weakness overcoming impossible odds. It was pondering existential questions in the only language available to her, and it was for that reason inherently religious.

Later I lived for many years in the interior forests of British Columbia in the Rocky Mountains. I can still remember the face of a little native-Canadian girl crouched by a mud puddle, arranging bits of broken glass, bottle caps, trash, and detritus from the forest, creating a miniature garden of Eden. Her face was so beautiful, so totally absorbed, so happy. Dressed in rags, she was busy about a holy task, that of restoring some vision of order and beauty to damaged creation.

I recall another man we knew for a few years, a dangerous man. He was a criminal who had spent most of his life in prisons. He became a friend of our family. His alcoholism was the release valve of a deep rage and sense of worthlessness. When he drank he was violent—relentlessly, mercilessly vicious. There were reasons for all this: He had been abandoned as a child. His mother had frozen to death. He had starved. When he eventually found his own father, he stabbed him. He tried to stab me once. And yet when he did not drink, he was like a lamb. Sober,

he had a rather sweet temperament, and he was always sincerely sorry whenever he disrupted our home. He begged our forgiveness. We always gave it and started over again. The point of this story is that he was one of the most gifted artists I have ever met. He was never a happy man; he lived in a twilight of perpetual anguish, except when he was painting or carving. Then, for a few brief hours, he was full of joy. I recall a bowl he made once in the shape of a highly stylized raven. It was so very much a work of genius that it belonged in a museum. I told him that. When I asked about it some time later, he shrugged and said he had sold it to a tourist for ten dollars. He bought a bottle of wine with the money and drank it.

I would not tell such stories if they were not part of a larger pattern that proceeds apace in the culture of the West. I do not exaggerate when I say that I know many writers, painters, and poets of outstanding talent who simply sink beneath the waves of our culture and never bear the fruit they are called to bear. That mediocrity and falsehood is everywhere exalted; that fortunes are wasted on junk, while things of irreplaceable beauty and truth fail to be born, or are created at superhuman cost only to be marginalized; that the spiritual sources which are the timeless origins of creativity have been largely blocked and displaced by commercial psuedo-culture—these are all factors which present not a few problems for the gifted person. His own dismay is his chief enemy. Lack of response from his society is his second. That there are exceptions to this pattern, sometimes glorious exceptions, the result of privilege, place, and cold hard cash, is no argument against the death of the imagination. They are exceptions which prove the rule.

Chesterton once wrote about Cobbett's history of the English Reformation that the Protestant Cobbett was a singularly honest man. Cobbett did his research well and came up with the politically incorrect conclusion that some enormous "unmentionable crime" had occurred in England.

I think the same phrase could be applied to the current state of Western culture: we have suffered some colossal but unmentionable tragedy that does not seem for the moment to offer much promise of changing for the better. Indeed it is so all-pervasive that in many places it has invaded the cultural life of the Church.

In *Painting and Reality*, Etienne Gilson laments that "churches have largely become so many temples dedicated to the exhibition of industrialized ugliness and to veneration of painted *non-being*."

In her book on aesthetics, *Feeling and Form*, the philosopher Susanne Langer confirms Gilson's analysis of most contemporary church art and adds that such works "corrupt the religious consciousness that is developed in their image, and even while they illustrate the teachings of the Church, they degrade those teachings. . . . Bad music, bad statues and pictures are irreligious, because everything corrupt is irreligious."

What, then, are the solutions? A return to classical iconography? That may be part of a restoration, but it certainly will not be all of it. Perhaps a return to some principles that the artisans of the medieval era understood? Perhaps we will want to return to some other period we have idealized? There are things to be learned in those directions, but these learnings are not the whole story.

Arthur Koestler, in his book *The Act of Creation*, says that we are now living in a period of "oversaturation" and that there are two alternative responses we can make to this: "emphasis" and "implicitness." He is saying by this that we can increase the voltage and pour on the stimuli in an attempt to grab the attention of the jaded modern imagination.

Or we can move in the direction of an economy of understatement, and through subtlety restore the appetites of modern man to simplicity. Although there is a truth here, I believe his either/or remedy is somewhat simplistic. We do indeed need to avoid the temptation to increase the dose of a bad drug. We do indeed need to grow in simplicity. However, there are other possibilities. Because art has an inherent restorative power, and furthermore because it always has an authoritative voice in the soul, we must trust that over time works of truth and beauty created from authentic spiritual sources will help to bring about a cultural reconfiguration and a reorientation of man. The question we need to ask is not so much what sort of surgery should be applied to a sick body, but what are the first principles of health.

Let us go back to some earlier periods in the history of the imagination to see if there are some things to be learned there.

THE ROLE OF IMAGERY IN THE OLD TESTAMENT ERA

I believe that the Sacrifice of Isaac was the seminal moment, and image, that represents and inaugurates the rise of the West. It was a radical break with the perceptions of the Old Age. When God led Abraham up the mountains of Moriah, He was building upon a well-established cultural pattern. Countless men were going up to the high places all around him and were carrying out their intentions to sacrifice their children. But God led Abraham by another way, through the narrow corridors of his thinking, to overturn his presumptions about the nature of reality. There was something monumental and irrational in Abraham's act of obedience. This was not a typical pagan, greedy for cultic power, for more sons or for bigger flocks. This was an old man who by his act of obedience would lose everything. He obeyed. An angel stayed his hand, and a new world began. From then on, step by step, God detached him from his thinking and led him and recreated him, mind

and soul. And thus, by losing everything, he gained everything. God promised it. Abraham believed it. Upon that hinges everything which followed in subsequent history.

The Old Testament injunction against "graven images" was God's long process of doing the same thing with a whole people that He had done in a short time with Abraham. Few if any were as pure as Abraham. It took about two thousand years to accomplish it, and the results even then were rough, inconsistent; even the best of the people experienced their failures. Idolatry was a very potent addiction—like all addicts, ancient man thought he could not have life without the very thing that was killing him.

Idolatry tends in the direction of the diabolical because it never really comes to terms with original sin. It acknowledges man's weakness in the face of creation, but it comes up with a solution that is worse than the problem. The idolater does not understand that man is so damaged at a fundamental level that power cannot heal him. Magic will not liberate him from his condition. It provides only the *illusion* of mastery over the unseen forces, the demons and the terrors, fertility and death. Ritual sex and human sacrifice are potent emotional experiences, yet they are stolen moments of *power over*, a temporary relief from *submission to*. They are, we know by hindsight, a mimicry of divinity, but pagan man did not know that. He experienced it as power-sharing, negotiating with the gods. To placate a god by burning your children on its altars was a potent drug. We who have lived with two thousand years of Christianity have difficulty understanding just how potent. God's adamantine position on the matter, his "harshness" in dealing with this universal obsession, is alien to us. We must reread the books of Genesis, Kings, and Chronicles. It is not an edifying record.

When God instructed Moses to raise up the bronze serpent on a staff, promising that all who looked upon it would be healed of serpent bites, He used the best thing at his disposal in an emergency situation, a thing which this apostasizing people could easily understand. He tried to teach them that the image itself could not heal them, but by gazing upon it they

could focus on its word, its message. The staff represented victory over the serpent, and their *faith* in the unseen Victor would permit grace to triumph in their flesh and their souls. And yet, a few hundred years later we see the God-fearing King Hezekiah destroying Moses' bronze serpent because it had degenerated into a cult object. The people of Israel were worshipping it and sacrificing to it. Falling into deep forgetfulness, they were once again mistaking the message for the Origin of the word. The degree to which they were possessed by the tenacious spirit of idolatry is indicated by numerous passages in the Old Testament, but one of the more chilling ones tells of a king of Israel, a descendent of David's, who had returned to the practice of human sacrifice. The Old Testament injunction against images had to be as radical as it was because ancient man was in many ways a different kind of man than we are. Even so, human memory is short: late Western man, post-Christian man, man without God, *homo sine Deo*, is descending back into the world of the demonic, complete with human sacrifice on an unprecedented scale.

THE INCARNATION OF CHRIST INAUGURATES A NEW COVENANT

Jesus Christ was born into a people just barely detached from their idolatry. Through a human womb God came forth into His creation. "An earthly tree, a heavenly fruit," as a medieval carol describes it. At last, God revealed an image of Himself, but so much more than an image—a *person* with a heart, a mind, a soul, and a face. To our shock and disbelief, it is a human face. It is our own face restored to the original image and likeness of God.

The Old Testament begins with the words, "In the beginning . . ." In the first chapter of John's Gospel are the words of a new genesis.

In the beginning was the Word,
and the Word was with God,
and the Word was God. . . .

And the Word became flesh
and dwelt among us.

Here we should note not only the content but the style. The text tells us that Jesus is Man and He is God. But it does so in a form that is *beautiful*.

Because the Lord had given himself a human face, the old injunction against images could now be reconsidered. Yet it was some time before the new covenant took hold and began to expand into the world of culture. Jewish Christians were now eating pork and abandoning circumcision. Paul in Athens had claimed for Christ the altar "to the unknown God." Greek Christians were bringing the philosophical mind to bear upon the Christian mysteries. Roman converts were hiding in the catacombs and looking at the little funerary carvings of shepherds, seeing in them the image of the Good Shepherd. Natural theology began to flower into the theology of revelation. Doves, anchors, fish, and hieratic Gospel scenes were at first scratched crudely in the marble and mortar, then with more precision. Hints of visual realism evolved in this early graffiti, yet Christianity was still the religion of the Spirit and the written word. In this regard I think often of an inscription on a marble plaque in the catacomb of San Callistus, the tomb of a thirteen-year-old girl martyred by the pagan Romans because of her refusal to submit to idolatry and sexual seduction—the words of the inscription leap like fire across the centuries:

"Sleep, little dove, without bitterness, and rest in the Holy Spirit."

Who cannot be moved by these words? Who can fail to sense a deep affinity with our little sister, our mother in the spirit? We will see her face to face one day, this small overcomer of lions.

Most important, Christianity is the religion of the Eucharist, in which word, image, spirit, flesh, God and man, become one. The Eucharist recreated the world, for the Word himself had become flesh, visible, accessible to our senses. And yet for the first two centuries the full implications were compressed, like buried seed, waiting for Spring.

THE ICON

When the Edict of Milan liberated the Church from the underground, an amazing thing happened: within a few years churches arose all over the civilized world. As that compressed energy was released, the seed burst and flowered and bore fruit with an astonishing luxuriance. The forms were dominated by the imperial Christ, who was portrayed on the domes of the apses in paint or mosaic. The architectural dome represented the dome of the sky, above which is the waters of the universe, above which is Paradise. This was no longer the little Roman shepherd boy, but a strong Eastern man, dark, bearded, his imperial face set upon a wrestler's neck, his arms circling around the dome to encompass all peoples, to teach and to rule the entire cosmos. He is the *Pantocrator*, the Lord reigning over a hierarchical universe, enthroned as its head—one with the Father-Creator and the Holy Spirit.

This strong emphasis on the transcendent Christ was not without its dangers. The possible alliance of the imperial powers of the State with the imperial Christ, for example. Or the possibility of losing the full significance of the humanity of Christ. Yet this was mitigated by the growth of small-scale iconography borrowed from the funerary encaustic painting of Rome and North Africa, bringing the Lord and his saints into practically every home. Believers sometimes wore icons on cords around their necks, blessed them and blessed others with them. Miracles and exorcisms occurred through the use of icons. The Holy Spirit was obviously anointing the practice. An unofficial theology of sacramentals

developed. And yet there was the danger of a subconscious lapse into the psychology of idolatry. There were abuses. From the third through the seventh century the Fathers of the Church corrected, instructed, encouraged—notably Saint Basil the Great, Saint John Chrysostom, Saint Gregory of Nyssa—but the spirituality and theology were still largely undefined; they badly needed clarification.

Saint John of Damascus (c. 675–749), writing in his *Concerning the Holy Icons*, made the major contribution to this end, pointing out that the Old Testament Jewish people honored the tabernacle that bore an image or *eikon* of heavenly things, the Cherubim overshadowing the mercy seat of the temple, and indeed the temple itself. These were handmade, "built by the art of men." Holy Scriptures spoke against those who worship sculpted images and also those who sacrifice to demons (*daimonia*). "The Gentiles sacrificed, and the Judeans sacrificed," John said, "but the Gentiles to demons and Judeans to God." Although he was insistent that for man to give form to the Deity (*Theion*) is "the height of madness and impiety," he reminded the faithful that God had now become man, not only in the *form* of man as he appeared to Abraham, but truly *in essence* man. Thus, to honor an image of Christ or the disciples of Christ is to honor the Lord Himself.

> Many times, doubtless, when we do not have in mind the Passion of our Lord, upon seeing the icon of Christ's Crucifixion, we recall His saving suffering and fall down and worship, not the material, but that which is represented . . .
>
> It is the same in the case of the Mother of the Lord. For the honor which is given to her is referred to Him Who was made of her incarnate. Similarly also, the brave acts of holy (*hagoi*) men stir us up to become brave and zealous, to imitate their virtues, and to glorify God. For the honor that is given to the best of fellow-servants is a proof of goodwill toward our common Lord, and the honor which is given to the icon passes over to the *prototype*. Now this is an unwritten

tradition (*agraphos paradosis*), as is also the worshipping towards the East and the veneration of the Cross, and very many other things similar to these.

That the Apostles handed down much that was unwritten, the Apostle of the Gentiles says in these words, "Therefore, brethren, stand fast, and hold the traditions which you have been taught, whether by spoken word or by a letter of ours" (2 Thessalonians 2:15). [1]

Saint John of Damascus made the clear distinction between idolatrous worship and profound veneration (*proskynousi*) or honoring (*timosi*). Nevertheless, this teaching did not prevent the horrific violence of the iconoclastic controversy, which disrupted the development of iconography in Byzantium for more than a century (726–843). This definitive crisis over the undefined doctrine was replete with riots, murders, martyrdoms, and the destruction of countless icons. The iconoclast heresy was rooted in a sort of early Puritanism, perhaps a longing on the part of many Christians to return to the rigid certainties of the Old Testament—perhaps, too, an early manifestation of the Protestant dogma of *sola scriptura*.

The Iconoclast Council of 754 decreed: "The guilty art of icon painting is a blasphemy. Christianity has overthrown paganism root and branch, not only the pagan sacrifices but the pagan images . . . From a sacrilegious lust for gain, the ignorant artist represents what ought not to be represented, and seeks, with his soiled hands, to give shape to what ought only to be believed in the heart."

The situation demanded a definitive teaching from the Church, and this was provided by the Seventh Ecumenical Council at Nicaea in 787, although the controversy continued to rage for many years after. The Council Fathers declared: "The more a person contemplates the icons,

1. Saint John of Damascus, "Concerning the Holy Icons," in Constantine Cavarnos, *Orthodox Iconography* (Institute for Byzantine and Modern Greek Studies: Belmont, MA, 1977), pp. 49–54.

the more he will be reminded of what they represent, the more he will be inclined to venerate them by kissing them, prostrating himself, without however, evincing towards them the true adoration which belongs to God alone, yet they are to be offered incense and lights, as are the holy Cross and the holy Gospels."

In the Monastery of Saint Catherine at Mount Sinai there survives a unique collection of Byzantine icons and manuscripts. A foundation of the emperor Justinian, the monastery managed to ride out the iconoclastic storm because of its isolation and other unknown factors. There are three very early icons there, which are possibly Roman in origin and are believed to be from the sixth century: one of Christ, one of the Apostle Peter, and one of the Holy Virgin. Although they are rendered with elements of stylization characteristic of classical Byzantine art, the warmth, naturalism, and humanity in them are absolutely gripping, especially in the face of Christ. It radiates presence. This is the Christ of the Gospels, the Man-God who teaches with authority. This man-size image is probably the oldest painted icon of the Lord in existence. It exemplifies an integration of the human and the divine that, I think, has not been equaled since then.

The mainstream of later Byzantine art tends increasingly to the highly stylized, stunningly beautiful symbol-sacramentals (the Orthodox Churches would maintain that the spirituality is closer to sacrament). It is overwhelmingly focused on the transcendent, theologically and artistically, forming a tradition that continues uninterrupted to this day, with the exception of pockets of late Western European iconography influenced by the Renaissance and the Baroque. In the remnants of the early icons at Sinai, however, there is a witness to what might have been, and perhaps to what still may be.

Saint John of Damascus once wrote that when Adam fell, man lost the likeness of God, but he did not lose the image of God. Only with Christ's redemption does it become possible for us to be restored to the original unity of image and likeness. The theology of the Latin West, no less than that of the East, was also concerned with the *Imago Dei*.

Whenever the awareness of man's complete identity declined, there were aberrations in the sphere of human activity. Culture expressed the rises and declines in this awareness like a barometer. For this reason, we should keep in mind the *Imago Dei* as we consider further developments in art history: for the struggle to sustain the awareness of who we are in relation to God and creation is the hidden dynamic of the historical imagination.

THE "DARK AGES"—THE MEDIEVAL ERA

For the sake of brevity we must now make some dizzying leaps across several centuries, centuries which include the collapse of Roman civilization, the rise of small medieval states, the development of monasticism, manuscript illumination, and chant. But we cannot fail to note in passing Saint Benedict's Rule, which transformed the face of post-Roman Europe, and which included for good reason a reminder to artists in the community that they remember always that their art must be subordinated to their monastic calling. I think also of Spanish-Byzantine iconography, in particular the commentary on the *Apocalypse* by an eighth-century monk, Saint Beatus of Liébana. A tenth-century artist named Maius, a monk of the Monastery of San Miguel, illuminated it with the flamboyant colors and unique iconography of medieval Spain. Manuscripts of Beatus' *Apocalypse* are in the collections of the Bibliothèque Nationale, Paris, the Biblioteca Nacional, Madrid, and the Pierpont Morgan Library, New York.

The imagery of the Morgan Beatus is dazzling. Purple dragons coil around the acid-yellow cities of man. Emerald seraphs spin the azure disc of the cosmos. Indigo scorpions sting their victims. Archangels plunge stiff from the heavens, swords outstretched, lit by neon. Gardens explode with ripe fruit, axes fall, heads roll off the martyrs' bodies like harvests in an orchard. Blood spurts, entrails spill. Rivers of ink spew from snake mouths. Trumpets blow. The messenger to the church at Sardis scowls

in warning: *You have the reputation for being alive; yet you are dead. Awake! Awake and strengthen the things that remain.* More trumpets blow. Blood! Fire! Flood! Two monks bear witness against the Antichrist. Hot gold light bursts from their lips. The Antichrist kills them as his servants dismantle Jerusalem, stone by stone. Hovering over all, the fierce face of Christ on his throne, waiting for the Last Day—the Great Judge—far more terrifying than the beast who gorges on the ruby flesh of saints.

There is an interesting little colophon inscribed at the end of the Morgan manuscript:

> Let the voice of the faithful resound and re-echo! Let Maius, small indeed, but eager, rejoice, sing, re-echo and cry out!
>
> Remember me, servants of Christ, you who dwell in the monastery of the supreme messenger, the Archangel Michael.
>
> I write this in awe of the exalted patron, and at the command of Abbot Victor, out of love for the book of the vision of John the disciple.
>
> As part of its adornment I have painted a series of pictures for the wonderful words of its stories, so that the wise may fear the coming of the future judgment at the world's end.
>
> Glory to the Father and to His only Son, to the Holy Spirit and the Trinity from age to age until the end of time.

There is a pun in the colophon. The reference to "small indeed" was no flourish of scribal humility, especially when measured against the artist's name, *Maius*, literally "major." It was a subtle joke, and we who live a thousand years later can smile and ponder the illusory nature of time.

There is so much to be learned from this period that I fear to do it injustice, to become bogged down in a complex of several important trails. We might discuss the Irish, for example, a subject that pulls me with a certain vertigo. We might dwell on Romanesque architecture. We might recall that the crucifix through which the Lord spoke to Saint Francis, instructing him to "go and rebuild my Church which is falling into ruins," was a Byzantine icon. And we really cannot bypass the influence of Saint Thomas Aquinas, whose writings so greatly affected his times and subsequent ages. Let me at least refer to two of Aquinas's important insights: *A work of art is a good in itself,* and *Beauty is a reflection of He who is perfect Beauty*—words that also leap like fire across the ages. When medieval man, much less wealthy than we are, created his churches and cathedrals, he did not merely make them sturdy and functional. They were not practical to heat or to maintain. But they were beautiful. Above all they were awesomely, instructively, mystically beautiful. Rooted in the earth, they soared heavenward.

In *Religion and the Rise of Western Culture*, Christopher Dawson says that medieval political philosophy was dominated by the ideal of unity:

> Mankind was one great society, and above all the regenerated human race, that portion of mankind which was incorporated in the Church was united by its membership of Christ, its Head, by its allegiance to the divine law and by its dedication to one transcendent end. This unity formed a complex hierarchical organism, a body with many members, each having a vital function to fulfill, each with its own office and ministry for the service of the whole.
>
> The doctrine of society involves the principle of hierarchical subordination at every stage, but unlike the Aristotelian theory it does not involve total subordination or the institution of slavery. For every individual member of the whole is an end in himself, and his particular *officium* or *ministerium* is not merely a compulsory social task but a way

of service to God through which he shares in the common life of the whole body. [2]

Dawson points out that "the feudal system rested in the last resort on the foundation of serfdom and on the power and privilege that were won and maintained by the sword, so that the feudal state could never entirely escape from the condition of anarchy and disunity out of which it had arisen. The medieval city, on the other hand, was essentially a unity—a visible and tangible unity, sharply defined by the circle of its walls and towers and centred in its cathedral, the visible embodiment of the faith and spiritual purpose of the community."

The cathedral of Chartres, for example, was built not only by engineers but by all kinds of men. Craftsmen and kings labored side by side, laying stone upon stone. It was expected that no one would put his hand to the task unless he was in the state of grace, and confessors were always on the site to ensure that this could be so. It is our best evidence that medieval man was imbued with the sense that matter itself is good, very good, and that it can be transfigured, that a stone is not just a stone. That a rose is not a rose is not a rose, with apologies to Gertrude Stein.

On the west portal of the cathedral of Chartres, there is a carving of Christ and Adam. In this image Christ faces outward, manly, solemn, strong, and behind him stands the naked Adam, tremulous but trusting, gazing over the shoulder of his Savior at the Beatific Vision. Christ is mediating. Christ stands *with* man and covers his nakedness before the face of the Father. This is not a prefigurement of the later Protestant doctrine of "imputed righteousness," in which Christ *hides* man's sin from God. It is in fact a purely Catholic understanding: Christ is here *restoring* Adam, in all his guilt and glory, to the original unity which he had before the Fall—to his dignity as a son of the Father. Interestingly, the art of the times was rarely signed. Sculptures of surpassing genius were not infrequently inscribed with the words, *Non nobis Domine, non*

2. Christopher Dawson, *Religion and the Rise of Western Culture* (Gifford Lectures, 1948–49) (Doubleday: Garden City, NY, 1958), pp. 171–172.

nobis, sed nomini Tuo da gloriam!—"Not to us, O Lord, not to us, but to Thy name be the glory." This is no indication that medieval man believed himself to be a non-entity. On the contrary, it is an indication that he found his ultimate meaning, his identity, within the living organism of Christ's Body, that in losing himself he was finding himself. Here was a humble Christian humanism, like that of the Roman iconographers of Sinai, who were also anonymous. Contrast this to the modern age of depersonalization, in which most every artist, including the Christian artist, takes pains over his public reputation and leaves nothing unsigned.

Dante is the figure who rises above the whole period as the exemplar of the Christian vision. He was late-medieval man, and perhaps also a precursor of what would be best in the Renaissance era, which was only just beginning during the final years of his life. Steeped in the learning of the Middle Ages, he had read the *Summa Theologica* of Aquinas and the encyclopedic works of the times, and most of what was then known of the Latin classical and post-classical writers. He was a poet-prophet, a man of both heaven and earth, who could speak of the greatest delight of his soul, his love for Beatrice, and find in her, and through her, a passage to the Beatific Vision. Dante's *Divina Commedia* begins with the poet losing his way in a gloomy woods and is consummated on the heights of the mystical pageant when he sees the face of his beloved Beatrice. Representing divine philosophy illuminated by revelation, she leads him up through nine moving heavens of intellectual preparation into the true Paradise where the blessedness of eternal life consists in the sight of God. There her place is taken by Saint Bernard, a type of loving contemplation, who commends the poet to the Blessed Virgin, at whose intercession he obtains a foretaste of the Beatific Vision, the "Exalted Light," the "Living Light" of the Holy Trinity, reigning at the uttermost heights of the hierarchy of existence. Material creation is neither to be annihilated nor escaped, but rather embraced as the path to the ultimate vision in which all powers of loving and knowing are fulfilled and consumed in a union with the Divine Essence who is Love. Love is the origin and the end. Love is the impelling force of the ascent. The citizens of the *inferno*

and the *purgatorio* have each in their way failed in some aspect of love. Love is the transfiguration of the immanent world and the path of real transcendence. Love is the unifying principle of creation. In the *Paradiso* Dante writes:

> Within its depths I saw ingathered,
>
> bound by love in one volume,
>
> the scattered leaves of all the universe.

Matter is good; it is very good. But it is not an end in itself.

THE RENAISSANCE

That material creation is a good, yet cannot be an end in itself, is a crucial distinction. With the rise of the Renaissance era, this distinction begins to blur and fade and is in danger of being lost during the period that comes after Dante. The imbalance in the humanism of the Renaissance is well illustrated, to my mind, by the painter Sandro Botticelli. Unquestionably a master, gifted with a fertile imagination and great charm, he was, like many of his contemporaries, intrigued by the possibilities of return to the culture of the classical age. Thus his Madonnas and his secular works, such as *The Birth of Venus*, are practically indistinguishable from each other, except for the degree of clothing worn by the central figures. But this nudity was not the classical pursuit of perfection as a means to a higher end. The *Venus* of Milo was not about sex; it was a search for harmony, the Greek concern for the divine order— *kosmos* triumphing over *kaos*. The new humanism of the Renaissance was more concerned with man's passions and powers than with his place in the "great chain of being." If man is the measure of all things, then why not explore his nature, his senses, his politics, his psychology as if they were ends in themselves? Even religious themes must be subsumed in

the service of this quest. Technical mastery, therefore, and the breaking of new ground, became a primary concern. Even the giant, Leonardo, anguished over a chronic sense of the insufficiency of his creative powers. Leonardo once wrote (I believe it is in his notebooks) that his greatest suffering in life was the gap between the images he conceived in his imagination and his ability to execute them in paint.

The preoccupation with mastery of technique, to the detriment of the word it was supposed to convey, is one of the primary characteristics of the Renaissance. However, we should not judge that period rashly. Let me illustrate this with a story:

Being a Canadian, I come from a country that is culturally very young. We ooh and aah over crumbling buildings that are about a hundred years old. In contrast, Europe's massive accumulation of cultural artifacts are overpowering to a visitor from the New World. This is not to say that we don't have culture on the other side of the Atlantic. We have some, though it is being swept under by the tidal wave of commercial culture, ersatz culture. We are also surrounded by a great deal of natural beauty. Our land is still largely savage and dangerous. It is beautiful, but it is raw beauty, much of it unmediated by the human hand. Perhaps Europeans view these things somewhat differently, but my North American friends who return from culture-forays into the Old World usually speak of what they have seen in tones of reverence, with a curious mixture of pain and exultation. For example, a friend of mine recently described his first encounter with Michelangelo's *David*. I am sure that everyone has seen photographs of this colossus. It is the most famous rendering of the tale of a lad who slew a giant against all odds and, through the transmutations of art, became another kind of giant.

I had never liked this statue of David for a number of reasons: its nudity seemed an aggressive assertion in the old dialogue between the rights of art and the call to prudence; its undeniable brilliance embodied what was unbalanced in the spirit of the Renaissance. It seemed to be potentially more an invasion of the imagination, rather than an incarnation of the true story of that little shepherd, a tale that is really

about the divine Spirit transfiguring human weakness. No, this carving seemed to be more about man's sense of his own power. This was no primitive stick man; it was a masterpiece of realism, but above all a triumph of *technique*. Moreover it had become in the ensuing centuries an overdone cliché. My friend confessed to me that he too had gone to Italy knowing that he would be taken on a tour of Florence, that he would see this work, and, of course, that he would be suitably impressed. But he felt the same aversion to it as I did.

During the tour he became separated from the group and, searching blindly through the corridors of the Galleria dell'Accademia, he came upon the statue from the wrong direction. Suddenly there it was. His first glimpse of it was from the reverse. Most of us have viewed it from the front, and from this direction we see a powerful body firmly planted on the earth, poised, balanced, muscular, set in its essential form, like the triumph of the will. But my friend saw it first from an entirely different vantage point: Viewed from behind, the figure appears to be glancing back over his shoulder. The image of the noble torso is here dominated by David's facial expression. The eyes, the mouth, the brows, the sinews of the face, are taut with an emotion which is so quintessentially human: a split second of uncertainty and a groping for faith, the moment when courage overcomes terror—not as animal instinct but as a spiritual decision. From the front it appears as an embodiment of confident resolve; from the rear it is about doubt. That was the artist's intention, and that is its *word*. It is concerned above all with the struggle of the human spirit.

Michelangelo's *David* is not about sex, it is about character. Although it raises some unanswered questions about prudence, it is in the same spiritual line as Andrea Del Castagno's painting of David, Masaccio's *Expulsion from Paradise*, and Donatello's champion *Saint George*, all of which are ultimately concerned with the dignity of man. All of which are far from the spirit of Donatello's *David*, which is a sensual bacchus or satyr dressed (or rather undressed) in biblical costumes. In that difference can be seen the central problem of the Renaissance.

How did my friend recognize the word in Michelangelo's *David*? How did I recognize it and thrill to the burst of new perception when he related his experience? We recognized it because this truth was already a living thing within us. The artist had exteriorized our own experience and given it a shape, a form, a name, an identity. We were able to step outside of ourselves and to look within. Art had liberated the perception, incarnated the invisible reality.

In Shakespeare's *The Winter's Tale*, Leontes says of a statue:

> I am overwhelmed: does not this stone rebuke me
> For being more stone than it?

In *A Midsummer Night's Dream* there is another passage that always moves me. Toward the end of the play Theseus says:

> More strange than true: I never may believe
> These antique fables, nor these fairy toys.
> Lovers and madmen have such seething brains,
> Such shaping fantasies, that apprehend
> More than cool reason ever comprehends.
> The lunatic, the lover and the poet
> Are of imagination all compact:
> One sees more devils than vast hell can hold,
> That is, the madman: the lover, all as frantic,
> Sees Helen's beauty in a brow of Egypt:
> The poet's eye in a fine frenzy rolling,
> Doth glance from heaven to earth, from earth to heaven;
> And as imagination bodies forth
> The forms of things unknown, the poet's pen
> Turns them to shapes, and gives to airy nothing
> A local habitation and a name.

Here we have Shakespeare the artist commenting through his dramatic persona on the nature of art itself. One might disagree with his comment if it were taken only in isolation, if we did not know his delightful sense of irony, and if we did not have the body of his plays, which is the fuller context, which bears witness over and over again to his belief that drama gives to invisible *realities* a local habitation and a name.

For all the new awareness of our humanity the Renaissance gave us, it galvanized forces that had been fermenting for centuries. It reinforced and accelerated the damage done by the divorce of the Church of the East and the West, the schism of four centuries before (AD 1054). What began as a difference in theological emphasis had begun to show fracture lines long before the official break and eventually opened a chasm, not only in the world of theology and ecclesial culture, but in the very structure of man's perception of the nature of reality. Until then a universal theology that was simply Catholic had more or less sustained the integration—the working relationship, if you will—between the human and the divine, between transcendence and immanence, between intellect and imagination, between beauty and truth, between law and spirit, between the hierarchical cosmos and (for all its flaws) the sociopolitical order.

That integration had never been perfect, and indeed any thumbnail summation of those centuries of transformation must pass too lightly over the many qualifications and exceptions. But the pattern was established: the intoxications offered to man in the discovery of his identity on a new frontier would prove irresistible. From the Renaissance onward, man became more and more concerned with himself, with his self-definition, and as a result he was to become increasingly a one-dimensional being. This was a consequence he could not have foreseen, because at the beginning of the "rebirth" he was saturated in the sensations of liberation. His brave new world could not yet appear to him as a kind of spiritual "flatland," for it was a time of beginnings, adventures, an explosion of possibilities. We who live at the culmination of a very brilliant and cruel century are the inheritors of the flaws in that vision.

In a 1946 article in the journal *Lumen Vitae*, Dawson writes:

> But if the combined influence of Renaissance and Reformation made for a wider diffusion of literary culture and the intellectualizing of religious education, it also tended to increase the practical and utilitarian elements of culture. Both the Byzantine East and the medieval West had shared the same ideal of contemplation and spiritual vision as the supreme end and justification of all human culture: an ideal that finds classical expression in St. Thomas and Dante. But from the fifteenth century onward, culture and education became increasingly concerned with the claims of the active life. This in turn led to the cultivation of the economic virtues of thrift and industry and to the acquisition of "useful knowledge" as the main end of education. There can be no doubt that secular utilitarianism was the direct product and heir of the religious utilitarianism that developed on the soil of Protestant and specifically Puritan culture. [3]

We cannot deny what was great in the Renaissance, nor can we ignore the fact that the post-Renaissance world needed a spiritual revival. But neither can we escape the suffering these periods have imposed on us. Humanism split off from the Catholic sense of the *Imago Dei* has not given us progress in any deep or abiding sense. It has given us the development of technique. It has given us the triumph of subjectivism. It has given us despiritualization, and despiritualization eventually has given us dehumanization, and dehumanization is now showing every sign of working out its terrible logic. In the end, unless there is a return to our true identity, the world will degenerate into the purely diabolic, which means the annihilation of man.

3. "Education and the Crisis of Christian Culture," *Lumen Vitae* 1:2 (April-June 1946): 210–212; adapted and developed in Dawson's *Understanding Europe* (Washington, DC: CUA Press, 1952), Part II, Chapter XIII.

Art has always asked the question: What is man? *Who* is he? Where is he going? These questions did not cease to be asked after the Renaissance. Neither did they fade from the picture after that second great blow, the Reformation. Yet from that point onward, the split widened and began to work out in *praxis* the consequences of its theory.

THE BAROQUE ERA

In *The Dividing of Christendom*, Dawson writes that the Baroque period following the Reformation has been viewed more or less negatively, but was in fact a positive development.

> Looked at from the Northern and Protestant angle, the baroque culture appears as a secularized version of medieval Catholicism; from its own standpoint, however, it represents rather the desecularization of the Renaissance and the reassertion of the power of religion and the authority of the Church over social life. All the resources of art, architecture, painting, sculpture, literature and music were enlisted in the service of Catholicism, and if to the Northerner the result appears theatrical and meretricious, this was due to no lack of spirituality. It was a passionate, ecstatic, mystical spirituality that has little in common with the sober pietism of the Protestant North, but it was intensely vital, as we can see from the lives and writings of the Spanish saints and mystics of the sixteenth century who initiated that great movement of Baroque mysticism which swept Catholic Europe in the first half of the seventeenth century. [4]

4. Christopher Dawson, *The Dividing of Christendom* (New York: Sheed & Ward, 1965), 197.

Dawson reminds us of the many giants who arose during that period: in the North, Saint Francis de Sales, mystic, humanist, and reformer; in the South, Saint Ignatius of Loyola and Saint Philip Neri; the ascetic ecstasy of painters such as El Greco, Ribera, and Zurbaran; the new church music exemplified by Palestrina. Shakespeare himself, says Dawson, although he transcends his time, can only be fully understood as "a Baroque genius," along with Cervantes, Galileo, and Bernini. He argues that contrary to the largely negative view of the Baroque period held by nineteenth-century art historians, we should understand it as a fairly successful attempt to restore the old integration. It created a new cultural unity based on a religious foundation. It diffused itself even in Northern Europe through the influence of the royal courts, which had become (with the exception of the Netherlands) the great patrons of art and culture.

It should be no surprise that as the movement evolved, the resurgence of religious sensibility gradually gave way to pomp and pageantry and the embellishment of the State. Fabulous interior decoration was indeed a pursuit of the lost ecstasy; however, it began to fail as it gradually mutated from a metaphor of Paradise into the metaphor of human domination and anthropocentric sensuality—no longer the transfiguration of the senses but a glorification of sensual experience as an end in itself. Some of it is exquisitely beautiful; some of it is obviously a desperate attempt to escape the cold winds of the anti-incarnational trends of the Reformation. I think of Rubens in this regard. Although he painted some liturgical pieces, including a theatrical tableau of the crucifixion of Christ and an operatic landslide of souls falling into hell, he was very much a man of his times, searching for the lost synthesis, yet achieving only a conglomerate of interests. I try not to think overmuch about his heaps of cavorting, very overweight, naked ladies. Why all that pink flesh? Why all the desperation to return to the bacchanal in the forest glade? Twentieth-century man, who has suffered from overexposure to flesh and underexposure to a sense of mystery, may marvel at the painterly technique, but he can barely resist a condescending smile. Poor Rubens,

we think, forgetting that we suffer a worse malady.

To return for a moment to the giants—the ones who in fact achieved a synthesis out of the collapse of the old vision: One thinks immediately of the Protestant Rembrandt, the tremendous humanity of the father figure in his *Return of the Prodigal Son*, or the immense dignity and pathos of his etchings of the passion of Christ. One cannot help but think of him of him as the spiritual companion of the Catholic El Greco. The dark brooding shadows of Rembrandt's northern Europe were not so different from the electric skies of Toledo, geographies of the soul that seemed backlit by photographic silver, as if every wintry Spanish landscape were a metaphor of a more vast spiritual landscape, as if nature itself, north and south, must writhe in anguish over the despoliation of man, as if all discreet coverings must now be torn off not only his flesh but off of his soul as well. This stream of post-Reformation religious painting radiates hope and dread wrestling at close quarters, as if words and anti-words threaten at any moment to burst from the plane of the canvas to overwhelm us with their most difficult questions. No longer was this the serene, ordered, baptized humanism of the iconography of Giotto, Cimabue, and Duccio, those Italo-Byzantine, early-Renaissance men. This was the new humanism of the West, striving mightily to retain the old Christian sense of God's victory over the chaos of the human condition. This is the best inheritance of the post-Renaissance age, a new iconography of man—man at war with himself and God; man losing the war, but in the losing finding himself again. This is incontestably sacred art. But it is no longer liturgical art.

Geniuses such as Rembrandt and El Greco were no longer the rule. They were phenomena, standing like lonely outposts, one might even say prophets, above a geography of lavish ornamentation, reaction, counter-reaction, and the increasing subjectivization of practically everything except science. When the world will not listen to its prophets, it must find other guides.

Scientism and the Enlightenment were the inevitable results. Both creation and human nature would henceforth be increasingly considered without reference to moral absolutes based in divine revelation. Man would become a purely social and political animal. And thus, by the reduction of the whole meaning of his existence, he would come to be regarded as a component in a bio-mechanism divorced from transcendent value. The result would be new forms of utilitarianism, new forms of slavery and ultimately of dehumanization. The mainstream of art would become anthropocentric and political. This limiting of man's moral cosmos generated in turn the cult of the secular genius extracting masterpieces from his divine self. Few artists would know how to sing *Non nobis Domine*. Everyone would sign their works. Everywhere would be seen a sliding into decorative effects or, alternately, a feeding on the stimuli of war and politics: Liberté, Egalité, the guillotine. Napoleon, Empire, the age of revolutions. Art must now serve the revolutionary new man, the masses. Delacroix, Gerricault, Goya: each of these admirable painters produced a mix of sociological romance and existential angst. Their era would contain much truth, much protest against a violated world, and much melodrama.

In the field of religious art the effects of Protestant Puritanism and Catholic Jansenism were also being felt. Each in its seemingly disparate way had over-reacted, overemphasized; each had denied the "whole truth about man," adding strain to the fundamental split in consciousness, throwing a pall of mistrust over everything sensual. The senses have proved themselves highly treacherous and well-nigh unconvertible, they said; therefore let us deny the senses or escape them. This viewpoint rejected the Catholic vision of the restoration of all things in Christ and replaced it with a mimicry of Catholic transcendence. Like all heresies, it left residual poisons in the system. Thus Christian art entered its most shameful period. It attempted to escape the gnawing sense of absence,

the numbness, the cold, by a plunge into emotional sentiment. Maudlin art arose from both Catholic and Protestant sources, the saccharine oleograph and the biblical etching replete with operatic effects and languishing gestures—these too, like their secular counterparts, were longings for a golden age that never really existed. It created a pseudo-religious culture that was a tragically stunted facsimile of deep religious experience.

THE ROMANTIC REACTION

And then followed the nineteenth-century Romantic movement. Here too are to be found many flashes of light, much that dazzles and delights. The starved emotions of Western man yearned alternately for a return to Nature, to the heroism of the Middle Ages, to the sensations of religious experience, or combinations of all of these. But the movement was really about feeling, bursts of mood and drama to feed the hungry imagination. It was also a subconscious attempt to return to mystery, imagination, wonder, and (unbeknown to many of its devotees) a restored moral order. Rossetti's *Girlhood of Mary Virgin* and Holman Hunt's *The Finding of Christ in the Temple* are touching works, but they are of a piece with other Pre-Raphaelite painting: absorbed in sensuous poetic imagination and dream. Drawing heavily on literary sources, lovely pastiches were created, richly colored, evocative, executed with finest draftsmanship. Renditions of the Arthurian legend and religious themes were usually indistinguishable in style. They approximated many of the book illustrations that enlivened adventure novels for the young. It was great stuff, but it lacked the exigencies of biblical faith; it owed little allegiance to the authority of the God of Mount Horeb and Tabor, nor to His Church. It was a movement anchored tentatively in reality, for the Romantics admitted that Nature can still teach us things. Aesthetic experience in itself, they said, is not only emotionally rewarding, it is instructive.

There were moments of real greatness: Wordsworth's "Lines Composed Above the Ruins of Tinturn Abbey," Tennyson's "Ulysses," and Matthew Arnold's "Dover Beach." Keats summed up the unifying ethos in "Ode on a Grecian Urn": [5]

> 'Beauty is truth, truth beauty',—that is all
> Ye know on earth, and all ye need to know.

We need to know a great deal more than that, but the Romantics did not really understand this. They thought they had stumbled upon a primary illumination when they had really found only a half-truth. But they did not seem to be aware that a beautiful half-truth can be far more misleading than an ugly lie. It was better than what had just preceded them, of course, and so they concluded that this must be progress. They were in reaction to what Blake called, in his poem on Milton, "those dark Satanic mills" of the industrial revolution. Their sentiments were often deeply religious, yet they did not seem to know, as Dante knew, that to play with the things of God without humility, as if these gifts were possessions or mere myths, to exercise spiritual power without submission to God's laws, was really a very old and dangerous error, one by which so many individuals and civilizations have fallen. Blake's mysticism, for example, was derived from cabalistic, alchemical, and Swedenborgian sources, and he was ever impatient with the codified ethics of organized religion. The nature mystics, for their part, were preoccupied with spirituality in a way that was essentially a pursuit of divinity *in nature*. Consciously or subconsciously, they were pantheists. The flight from materialism was laudable, but it failed to produce a definition of man that encompassed the full meaning of his identity. Thus it could not hope to provide the needed resistance to the dehumanizing trends of the times, trends that grew into colossal forces and that eventually unleashed the crimes of the twentieth century.

5. For the purpose of defining their common ethos, I have here deliberately linked the Victorian poets Tennyson and Arnold with the Romantics.

In his *Annotations to Sir Joshua Reynolds's Discourses*, Blake makes a valid point:

> Degrade first the arts if you'd mankind degrade.
> Hire idiots to paint with cold light and hot shade.

Blake saw many things rightly, even to the point of prophetic clarity. But many things he judged wrongly, among them Christ's Church. Despite his heroic effort to respiritualize his times with hot light and hotter verse, and for all his longing to build Jerusalem "in England's green and pleasant land," Blake's religion was a prodigy of subjectivism. His visions had no counterpoise in the imperatives of Divine law and Church law. A century and a half after his death, by the end of the twentieth century, the triumph of subjectivism had become well-nigh universal. The dark Satanic mills had been succeeded by brightly lit Satanic laboratories.

IMPRESSIONISM

The Impressionist movement in art followed the Romantic period. Who cannot love the Impressionists? Who can fail to admire them? Who among us does not have his favorite painting or two, or twenty? Reacting against the massive urbanization of the nineteenth century, the slums, drabness, and dehumanizing toil, and following the lure of the hint of transcendence that is indeed written into nature, they played with color, movement, and harmony, all of which they accomplished by the fracturing and reassembly of light. But this fracturing process necessarily involved a blurring of distinctions—of identity. The reassembly did not often produce a resurrected being, but rather a sense of all existence dissolving into the ultimate identity of cosmic light. Man is often absent from their paintings, and even the works of man, cityscapes, bridges, the back yards of homes, are treated as extensions of nature, as if they too are

prismatic beams of that single, unifying principle of light. The effects are startling, moving, and they are, I think, a valiant attempt to find fugitive beauty in the midst of the industrial revolution. They are fundamentally spiritual, but they are a spirituality in the line of monism.

The post-Renaissance developments in art have given us a very great gift, and that is the understanding that the subjects of art are practically limitless. Nevertheless, the artist's ability to explore the new frontiers are still, as always, dependent upon his capacity for truth, and equally important, his capacity for love. Art, which is acknowledged widely as an act of love, will *be* an act of love to the degree that it is also an act of truth. It is a form of communication that can only occur when there is faith in the possibility of *communion* between human beings, and moreover faith that there is something to communicate which gives life. I think the Impressionists succeeded to a degree. They restored man to consciousness of the beauty of nature. They reverenced its truth and loved its light. Although they did not expand our understanding of the ultimate meaning of light—which is a reflection of Uncreated Light—they contributed momentously to the expansion of the eye's grasp. Their purpose was not to teach—Art usually fails when it attempts to be didactic. Their purpose was to impart the reality, not to talk *about* it. They brought a joyful, contemplative sense back into the gallery and (after the development of inexpensive printed reproductions) into the home. They also showed us that there is still a kind of natural theology at work in the consciousness of secular man, that fertile ground is there, waiting for revelations, perhaps still open to signs of a much vaster and more beautiful kingdom than even nature itself can offer.

Though solitary figures like the Catholic Cezanne and Protestant van Gogh were religious men, they, like most of their contemporaries, were the inheritors of that rendering-down process which robbed post-Renaissance, post-Reformation, post-Enlightenment man of his sense of the hierarchical cosmos, a creation that contains light but is not Light itself. What the Impressionists achieved is glorious but symptomatic.

The Cubists followed swiftly upon the heels of the Impressionists. They too believed they were pushing back the frontiers of the possible. Pablo Picasso stated, "Art is a form of magic designed as a mediator between this strange hostile world and us, a way of seizing power by giving form to our terrors as well as our desires" (F. Gilot, *Life With Picasso*). In 1945 he said that painting was "an instrument of war for attack and defense against the enemy." He did not mean only the political chaos which his generation had just suffered through. No, the "enemy" is the hierarchical order of the universe—its cosmology— containing the authority of Natural Law, the necessity of conscience, and the institution which proclaims the right formation of conscience. When these have been denied, the artist-as-protean-being can then create his own conscience. He becomes a self-appointed lord *over* life. Picasso thought that by dissecting the structure of reality he could reassemble its constituent parts—abstracted, purified, mastered. When personhood has been negated, identity disappears. Why not dissect the corpse? The results, though certainly impressive, were at the same time cold. He could not bring anything back to life. Possibilities for wider expression were evidenced in works such as *Guernica*, Picasso's protest against the Fascist bombing of the city of Guernica during the Spanish Civil War. It is interesting to note, however, the one-sidedness of art when it becomes the servant of a political ideology. In Picasso's work there is no parallel outrage against the Communist's willful destruction of hundreds of Spanish churches and countless cultural works, nor their murder of more than 6800 clergy and hundreds of thousands of Catholic laity, not to mention the many millions murdered by the Soviet empire. The rage of *Guernica*, that brave new icon of the humanist's cry for "justice," falls far short of universal compassion.

Various art movements have emerged since the first decades of the twentieth century. The common theme that unites them, beneath their

differing styles and ideological feuds, is an immanentized cosmos. The transcendent God is dead. Perhaps man too is dead? Burdened with the colossal weight of this question and the "silence" of God that greets it, the culture of negation has arisen. Manifestations range from the poignant, the silly, the cynical, the simply empty canvas, to eruptions of the diabolical. For example, in February of 1990, some five hundred works of art and several artists were brought from the former East Germany to Paris by the French Ministry of Culture. In one typical work a live woman was covered in cattle blood and her male counterpart enacted a mock castration with a chainsaw. Nudity and butchery were everywhere, and though the exhibit was hair-raising and nauseating, it was not the most extreme art event that has occurred in recent years. It is important to note that preoccupation with absurdity, violence, and death is not peculiar to artists oppressed by their governments. It is endemic to all postwar Western societies. With the fall or decline of overt tyrannies we must not assume that man will now right himself and produce works of art restored to a sense of beauty, truth, and virtue. The opposite may occur, if the East German exhibit is an accurate barometer. The locus of the revolution may be shifting from the exterior political sphere and plunging into the interior, riding on the vehicle of public culture. In that way it may penetrate to the soul of man in a way that violent regimes never can, for they alienate their citizens, rendering them perpetually on guard. The most effective revolution is the one that appears to be a liberation.

In the West, most public galleries devote literally acres of exhibition space to abstraction and absurdity, to the demolition of the image of man. At the same time they squeeze contemporary realism into obscure side galleries, when it is not altogether in storage. This is most revealing: hierarchy cannot be avoided in human affairs. As the revolution becomes the establishment, it imposes a new hierarchy of values on the people. Yet in order to maintain the illusion of freedom, the new cultural elite must pay lip service to pluralism. Everyone is equal. Everyone must have his share of the public forum, including the devil, because in "Flatland" no

single truth is better than another. In practice, however, it is found that some of us are more equal than others.

I have frequently heard from otherwise sensible people that the last remaining tyranny left on the planet is the Roman Catholic Church. The English painter Francis Bacon, who I think epitomizes the spirit of the postwar generation of painters, has produced a series of portraits reinterpreting Velasquez's paintings of a pope. Bacon paints the pope encased in glass, a schizoid screeching face with the top of his skull blown off. Bacon says, "Man now realizes that he is an accident, that he is a completely futile being . . ." (J. Russell, *Francis Bacon*).

The blatantly anti-Catholic blasphemy-artist Andres Serrano, the photo-pornographer Robert Mapplethorpe, and the horror-sculptor Mark Prent are his heirs. Whether or not such artists are aware of it, the underlying impulse is the need to demolish any claims that spiritual authority might have on the conscience and the imagination. It is an assault on the hierarchical cosmos, and ultimately against the principle of fatherhood, the source of which is God the Father. This is not Goya protesting the horrors of war; this is rather the consciousness which creates the horror, and celebrates it, and would enshrine it as the highest art form.

Lines from the *Purgatorio* come to mind:

> O human race, born to fly upward,
> Why, at a little wind, do you so fall?

THE FRUIT OF MODERNITY—MAN WITHOUT GOD

Unless there is a return to the search for the *imago Dei*, man will continue to fall down two main false trails: on one hand an increasing sterility, rage, absurdity, and nihilism; and on the other hand a return to cultic paganism. This is more than a theoretical possibility. It is a growing phenomenon.

A few years ago I was asked to be a judge at a juried exhibition of Christian art. Only a minority of the pieces submitted could be called in any reasonable sense Christian, for a great deal of it represented young artists submitting to peer pressure, the need to show that they were *au courant* with the latest-breaking developments in art history. Many of them were the victims of a certain *cold rationalist gnosticism*. Another well-represented genre was a predictable exercise in heroic revolution—a lukewarm Catholic version—which is to say these paintings were didactic vehicles of deformed theology which were a kind of *neotheo-gnosticism*. Then there were the cultists, the new *hot pagan gnostics*. I recall one Catholic artist in particular, a nice young woman who had obtained a master's degree in theology, was highly gifted as a painter, possessed a gentle nature, was intelligent and intensely sincere. With considerable pride she showed me one of her recent paintings. It was a work of artistic merit, technically speaking, quite visually pleasing. It was a self-portrait, she said. Titled *Icon*, it depicted a pile of snakes writhing in the womb of the central figure.

Somewhat horrified, I asked her why she had done this. Judeo-Christianity, she explained, had unjustly maligned the serpent. And in order to rehabilitate this symbol it was necessary to take the serpent into her womb, to gestate it, and eventually to bear it into the world as a sacred feminine icon. I pointed out that the meanings of symbols are not merely the capricious choices of a limited culture. We cannot rearrange them like so much furniture in the living room of the psyche. To tamper with these fundamental *types* is spiritually and psychologically dangerous because they are keystones in the very structure of the mind and reinforce our understanding of the shape of reality. They are a language about good and evil: furthermore, they can be points of contact with these two realities. To face evil without the equipment Christianity has given us is dangerously naïve. But my arguments were useless. She had heard a better tale from a famous theologian. When I refused to hang the picture in the exhibit, this gentle person became unexpectedly ferocious, and displayed all the moral outrage of the unjustly condemned. I would guess that she considered me a Catholic version of a KGB bulldozer.

Though many a neopagan artist retains the word "beauty" in his vocabulary, and strives for some beauty in his work, by and large he no longer possesses the ability to reflect on why beauty exists, and how it relates to a higher order in creation. The connections are broken. He looks at what is good and no longer sees its real value. And if the meaning of good has been thus distorted or vanquished, what then is to happen when he looks at evil? Will he succumb, as indeed more and more creators of culture do succumb, to the fascination of evil? Will he be excited by its possibilities, both sensual and mysterious?

Accompanying the rise of new cultic paganism is a pure materialism without any spiritual content. Both avenues offer extreme peril for the destiny of human souls. Even so, we must not despair of human nature, for written within us still is the *imago Dei*. Several years ago I attended the World's Fair in Vancouver. The theme of the Fair was Transportation and Communication. I wandered through the pavilions for a day with my children, a mind-blowing over-saturation in the technological society. However, I noted that there was a marked lack of art in the entire exhibit, a departure for world fairs. The little in evidence was consistently political art or industrial art. At the main plaza of the site rose its centerpiece, a solid gold coin, man-size, worth hundreds of thousands of dollars. It was an overgrown model of the Canadian one-dollar coin, on which is emblazoned a northern water bird called the loon. This cheap brass coin is generally referred to in my country, with a certain irony, as "the loonie." It is our golden calf.

As I was heading toward the exit at the end of the day, children in tow, I was feeling quite despondent. The whole affair seemed really like some great temple erected in honor of our current deities. I was lamenting to my oldest son the absence of real art when he grabbed my arm and tugged, pointing back to a pavilion which we had somehow missed in all that maze of industry and commerce.

"Dad, Dad," he urged, "Cheer up! There's some art!"

And sure enough, rising above that mini-city of sterilized architecture, affixed to the wall of a giant box-shaped building, was a

very beautiful sculpture. Twenty or thirty feet high, it depicted a man dressed in flowing robes with his arms raised to the heavens. Intrigued, I thought it must be a priestly figure, and assumed we were seeing the back side of the Christian pavilion. We retraced our steps to the entrance and found to our utter surprise that it was the Soviet pavilion. The sculpture was titled *Cosmos.*

You must remember that this was 1986 and there were no signs that the Soviet empire was soon to fall. But it struck me that even after seventy years of a relentless effort to crush and pervert religion, the tyrant-State could not eradicate intuitions that live at the very roots of the soul, in the catacombs of the imagination, and may at any moment emerge in disguised forms.

I once had a conversation with an exiled Russian painter, an enlightening encounter for me. This was in the early 1980s, and he had just come with his wife and little daughter from Moscow, the beneficiaries of that brief thaw which permitted thousands of Jewish people to emigrate from the Soviet Union. He had been a professor at the Moscow Art Institute, a privileged citizen-artist with a salary and a dacha. He had lived a kind of double life during his last years there, and had exhibited at the famous free exhibit held in a Moscow park, a show of dissident art that KGB bulldozers had flattened. Dismissed from the Institute, hounded by the KGB, half of his friends dead or missing, he seemed to me a dark, driven soul. I made the naïve comment that now he must be very happy to have become a free artist in the West. He gave me a look of pity and growled, "In Moscow we were suffering. We were dying and starving, but we loved each other. We looked at each other's work and we understood it."

"He hates your country," his wife said.

"He does?" I replied, amazed.

"Yes, I hate your country," he said. "There they kill us, but here they kill the heart. You are already dead! You are a dead people!"

A violent complex emotion was released in these harsh words, a reaction that we ignore at our own risk. He gave voice to what is felt by

most expatriate artists in my acquaintance: they feel that the people of the West have by and large become unable to understand what is being said to them. We listen without hearing, look without seeing. It is not that the émigré artist produces imagery too esoteric for comprehension or limited by provincial experience. On the contrary, his suffering has allowed him to break through to universal truths, the perennial object and language of art.

For several years I have entered my paintings in a national exhibit of religious art in Toronto. Always, and I underline the word *always*, the very best work in those shows is produced by refugee artists from Russia, Ukraine, Poland, Hungary, Romania, Czechoslovakia and so on. Their work radiates authenticity. It has integrity of content and mastery of form. There are, of course, untalented ex-Soviet artists and some very fine Western ones, but the general pattern is sharply defined. The work of the exiles is consistently superior, technically and spiritually, to North American work, which on the whole is mediocre, and at its best is usually clever posturing. I dread to think what these Eastern and Central European people think of us. Our only excuse may be to recall that the culture of negation, which took seventy years to germinate and ripen its deadly fruit under the pressure of brutal dictators, has been no less relentless in the West, and in fact by evolving smoothly and efficiently in the democracies may in the long run prove the most effective form of violation. There has been little public violence to alert us to our peril. No jackboots, no incarceration in gulags or state mental institutions, no falling into the pit of official non-personhood. Yet a large number of artists disappear from the cultural life of the West, dying not from grotesque assaults but from a slow, discreet suffocation.

The artist today suffers in all aspects of his being. Of the two obstacles facing him, the exterior and the interior, it is difficult to say which is the more formidable, but I am inclined to think it is the interior. Practically all artists now suffer from what T.S. Eliot called, in an essay on the metaphysical poets, "the dissociation of sensibility." Unification of thought and feeling becomes more difficult to the degree that the artist is an atomized individual, adrift in time, grabbing at sense and sentiment as if to anchor himself in a weightless cosmos. In his famous essay, "Tradition and the Individual Talent," Eliot suggests that the remedy is to be found where it has always been found, by obtaining "by great labor" a sense of tradition. The historical sense, he says, is a perception "not only of the pastness of the past, but of its presence. . . . This historical sense, which is a sense of the timeless as well as the temporal and of the timeless and the temporal together, is what makes a writer traditional." Eliot makes the distinction between a vital sense of tradition and *traditionalism*, which fixates on certain periods of artistic "success" and will not budge from them.

> What is to be insisted upon is that the poet must develop or procure the consciousness of the past and that he should continue to develop this consciousness throughout his career.
>
> What happens is a continual surrender of himself, as he is at the moment, to something which is more valuable. The progress of an artist is a continual self-sacrifice, a continual extinction of personality. [6]

6. "Tradition and the Individual Talent," in T.S. Eliot, *Selected Essays* (New York: Harcourt Brace, 1932).

These are strong words. I do not think Eliot means by *extinction of personality* some form of self-annihilation or a succumbing to the dehumanizing forces of modern civilization. I believe he means by this a turning away from all that feeds the *false* self—egocentricity, the cult of artist-as-personality. He is pointing toward the tradition of the icon painter and the Gothic sculptor, who believed they were finding themselves as they lost themselves, content to be at play in the fields of the Lord, in an ordered, creative universe suffused with grace.

Grace is our word. The unification of feeling and form, intellect and imagination, spirit and talent, past and present, *Logos* and man-made words, can only be rediscovered to the degree than we surrender to grace. "Everything is grace," said Bernanos, echoing the saints. Grace is everywhere. Sanctifying grace. Actual grace. Extraordinary grace. Grace in torrents. But we have forgotten how to ask for it.

Is it too late for us? No, it is not. Numerous works of art are being born from us, all around us. I think especially of Henryk Goreckie's magnificent *Symphony No.3*, his cycle of sorrowful songs memorializing the suffering of man, with its meditations on the *shoah*, the holocaust. It is reported that when this work was first played on public radio, people listening to it on their car radios while driving the hallucinogenic, utterly dehumanizing New York State throughway, pulled over to the curb, and wept. They could not explain their reaction. Why did they weep? What faculty, long suffocated, was liberated through the medium of this work of art?

I think also of Rachmaninoff's *Vespers*. Of the films of the Russian Christian Andrei Tarkovsky, especially his *Andrei Rublev*. Of the Italian film *The Tree of Wooden Clogs*, by Ermanno Olmi, which to everyone's amazement won the Grand Prize at Cannes in 1978. I think of the fiction of William Golding, especially his novel about original sin, *Lord of the Flies*, which is also a stark analysis of the thinness of civilization's veneer; his exploration of prophecy and apocalyptic themes in *Darkness Visible*; and *The Spire*, which is about the building of a medieval cathedral, which is really about the tension between man's longing to transcend

through creating and his abiding impulse to self-divinization. I think of Georges Rouault's heroic effort to baptize abstraction, his incandescent paintings of Gospel scenes and his crucified Christ from the solemn Miserere series. I think of Cezanne's tabletops full of fruit that proclaim the miraculousness of the ordinary, imparting to us the realization that nothing, simply nothing, is ordinary.

I think of Solzhenitsyn's hero Oleg Kostoglatov in *Cancer Ward*, who in the final lines of the novel, a free man at last, liberated from the Gulag, and from internal exile, and healed of his cancer, lies down in a train carriage and is suddenly seized with anguish. He buries his face in his coat (which is his only home), leaving us with the incontrovertible sense that the greatest cancer is unseen, and is within the soul, waiting to be faced. Implicit in Oleg's willingness to feel again is the promise of resurrection, waiting for us, there, within, if we would only believe. Elsewhere in *Cancer Ward* Solzhenitsyn quotes Pushkin: "In our vile times . . . man was, whatever his element, either tyrant or traitor or prisoner!" I think it can be said that we are all prisoners, but the Christian is a prisoner in Christ and with Christ, and thus he is the only free man on the planet.

I think of a painting by Constance Stokes, *The Baptism*, which hangs in the National Gallery of Victoria, in Melbourne. In this work Christ and John the Baptist stand in the Australian desert, its landscape and sky defined by gashes of cobalt, cerulean blue, burnt orange, and sienna, expressing an epiphany of stillness and presence that is rarely equaled in these times.

I think of the Canadian Catholic painter William Kurelek, who painted a mural of Christ titled *Toronto, Toronto*, echoing the Lord's lament over Jerusalem. A marvel of "explicitness," it depicts the savior of the world standing on the steps of Toronto's city hall with his arms spread wide, beseeching the crowds of busy shoppers and the hurtling traffic to stop, to listen. Only a single child in the hundreds of passersby is able to notice.

"Wisdom! Be attentive!" resounds the proclamation of the Byzantine Divine Liturgy, just before the Word of God is spoken. We are hardly able to notice. We are too busy. We seldom hear. We can barely see. We have no time. We do not attend the Great Liturgy of being in which we are always and everywhere immersed.

John Paul II has frequently warned the people of the West that materialism is far from dead and may in the long run bring about a more comprehensive destruction of the human community by turning man into a consumer without conscience. For materialism, which is the bed of modern humanism, seeks to erase "the whole truth about man" one way or another. And beyond humanism lies the ominous realm of the anti-human, the anti-word and the final anti-word—the destruction of everything, the ultimate denial of our powerlessness. To have power *over* life, and to have it on the level of totality offered by nuclear warfare, may prove irresistible—Nietzschean cataclysm as the final art form.

The antidote is humility. We must begin where the path always begins, by becoming empty in order to be filled. To be silent. To be still. To wait. To listen. To feel in our bones that we are creatures. To raise our hands, childlike, in the *orans* position, asking for grace.

To *rejoice* in our powerlessness, to find again our simplicity, and thereby to discover our true greatness. To know that we are damaged but not destroyed. To learn that within us is a repository for truth and for love, and a potential for forms of creativity that are practically infinite. These are gifts, but they are not our possessions. They are not our power *over* creation but an act of love made *with* creation and in honor of He who lives beyond and within creation: He who is perfect beauty, perfect truth, perfect love.

Not until we see a movement of gifted people turning away from materialism, willing to be empty, willing to be poor, willing to be filled with something other than their ambitions and fabricated self-images, will we see a true renaissance, a second spring. I believe that a rebaptism of the imagination is already happening. It is small, fragile, but quite capable of overturning the culture of death. I believe that as it gathers

momentum we will find again, to paraphrase Shakespeare, our home and our own true name.

A new iconography is waiting for us; it will be built upon all that the historical imagination has given, but reinvigorated by a new consciousness. Our perceptions, more accurately our *soul*, will be restored to divine order when we find again our proper place in the hierarchy of creation. In submission to natural and supernatural law, to the absolutes, in obedience and prayer, by opening our interior life and the intellectual life to the full authority of the Holy Spirit, we will germinate a little seed. And from it entire forests can spring and may yet cover the earth.

> In the beginning was the Word,
> and the Word was with God,
> and the Word was God. . . .
>
> And the Word became flesh
> and dwelt among us.

And that has made all the difference.

Born in Ottawa in 1948, Michael D. O'Brien is the author of twenty-eight books, notably the novel *Father Elijah* and twelve other novels, which have been published in fourteen languages and widely reviewed in both secular and religious media in North America and Europe. His essays on faith and culture have appeared in international journals such as *Communio*, *Catholic World Report*, *Catholic Dossier*, *Inside the Vatican*, *The Chesterton Review* and others. For seven years he was the editor of the Catholic family magazine, *Nazareth Journal*. Since 1970 he has also worked as a professional artist and has had more than 40 exhibits across North America. Since 1976 he has painted religious imagery exclusively, a field that ranges from liturgical commissions to visual reflections on the meaning of the human person. His paintings hang in churches, monasteries, universities, community collections and private collections throughout the world. Michael O'Brien lives near Combermere, Ontario. He and his wife Sheila have six children and eleven grandchildren.

CPSIA information can be obtained
at www.ICGtesting.com
Printed in the USA
JSHW020449050521
14288JS00001B/8